CW00825992

A CAT COMPENDIUM

The Worlds of Louis Wain

Also edited by Peter Haining and
published by Peter Owen

Wilkie Collins, *Sensation Stories: Tales of Terror and Suspense*
Hunted Down: The Detective Stories of Charles Dickens
H. Rider Haggard, *Hunter Quatermain's Story*
Midnight Tales: The Horror Stories of Bram Stoker
Edith Wharton, *The Ghost-Feeler: Stories of Terror
and the Supernatural*

CAT COMPENDIUM

The Worlds of Louis Wain

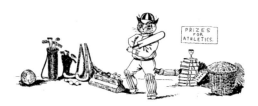

Edited and introduced
by Peter Haining

Peter Owen
London and Chester Springs

PETER OWEN PUBLISHERS
73 Kenway Road, London SW5 0RE

Peter Owen books are distributed in the USA by
Dufour Editions Inc., Chester Springs, PA 19425-0007

First published in Great Britain by
Peter Owen Publishers

ISBN 0 7206 1229 2

Printed in Singapore by
Excel Print Media

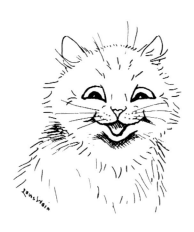

In memory of
Chippy, Spec, Tickles, Kevin and Sluggy
And for Edward,
occasionally known as Prince

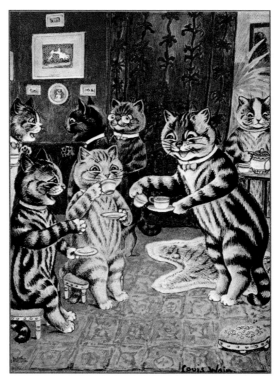

'Louis Wain has made the cat his own.
He invented a cat style, a cat society, a whole cat world.'
– H.G. Wells, August 1925

ACKNOWLEDGEMENTS

This book would not have been possible without the discovery in an attic of a collection of cuttings and illustrations by and about Louis Wain that had been assembled over half a century ago by one of my relatives. The lady had been a life-long cat lover and an admirer of Wain's pictures, which she had clipped from newspapers and magazines – and even a few books – and carefully mounted in a scrapbook. It is from the pages of this scrapbook that the articles and pictures by Wain have been selected to give as wide-ranging an indication of the man and his talent as possible.

The task has been one that I have enjoyed immensely, and I am delighted that it has been possible to include a selection of very striking and often most unusual full-colour illustrations that Wain created especially for the various magazines and books to which he contributed. The captions to a number of the pictures were those that the

owner of the scrapbook had written beneath them, so if any sharp-eyed expert has reason to believe the words may be different from those that Wain originally wrote, I apologize now. The pictures, of course, speak for themselves and hardly require any words!

I should also like to thank the following for their assistance in making this book possible: my friends Chris Scott, Nita Rigden, Denis Gifford, Chris Beetles and the late Bill Lofts, who tracked down the copy of Wain's extremely rare article 'How I Draw My Cats'. I am also grateful to the staff of the British Newspaper Library at Colindale for checking a number of publications and dates for me; also the publishers Thames and Hudson for permission to quote from *Louis Wain's Cats* by Michael Parkin, and Michael O'Mara Books Ltd for the extract from *Louis Wain: The Man Who Drew Cats* by Rodney Dale. All other sources are acknowledged in the text.

Peter Haining
Boxford, Suffolk

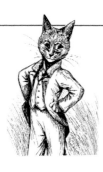

CONTENTS

The archetypal Louis Wain cat
(*The Idler*, January 1896)

THE WORLDS OF LOUIS WAIN

In the spring of 1929, Bethlehem Royal Hospital in St George's Field, Lambeth, was a mental institution regarded with a mixture of pity and fear by many Londoners. The tall, somewhat forbidding building was, in fact, still referred to by some locals as 'Bedlam', and local gossip would occasionally refer to the hospital's past when curiosity-seekers went there to stare and make fun of the extraordinary antics of the lunatics locked in their cells.

By the 1920s, however, the Bethlehem was acknowledged as the world's oldest psychiatric hospital, and its history had been traced back as far as the thirteenth century. Originally located in Bishopsgate, where it had been a priory for the men and women of the Order of the Star of Bethlehem, it had, by the following century, become a hospital and in 1377 began treating 'distracted' patients.

It was during the reign of Henry VIII that the institution became notorious for the inhumane and brutal way in which the inmates were treated and became known as Bedlam. In 1675, the hospital was moved to new premises in Moorfields, and soon after that the freak shows began. These appallingly insensitive 'open days' allowed the citizens of London, for the price of a penny, to enter the buildings and amuse themselves at the expenses of the hapless inmates.

The hospital was immortalized in the public imagination in 1735 by the artist William Hogarth in a scene from *A Rake's Progress*, in which the terrible fate of a merchant's son whose debauched lifestyle had brought about his incarceration is depicted – reflecting contemporary medical opinion that madness was caused by moral weakness. Thankfully, a change in attitudes was soon forthcoming, inmates now being referred to as 'patients' and separate wards set up for the 'curables' and 'incurables'.

The scars of the past could not be entirely erased, however. The word bedlam was already in common usage for all lunatic asylums, as well as any place or scene of wild turmoil and confusion. The name 'Tom O'Bedlam' had

similarly been coined to describe anyone who was discharged from the hospital and provided with a small tin plate so that he could legally beg on the streets of London.

The nineteenth century saw the Bethlehem Royal Hospital move a third time, to Lambeth, where it would remain until 1930, before becoming what is now the home of the Imperial War Museum. These new premises proved a far cry from the horrors of the old Bedlam – although some of the misconceptions about the place still persisted – individual rooms being provided for patients along a series of galleries.

In 1929, Room 7 on Gallery 2 was occupied by a quietly spoken man in old-fashioned clothes who gave the impression to staff and visitors alike of being more of an eccentric than a madman. Certainly his room was piled high with paper, books, newspapers, magazines and a host of other smaller items indicating that he was a hoarder, while his constant preoccupation with writing and drawing set him aside from most of the other patients.

Matters came to a head that spring when the authorities finally insisted that Room 7 had to be cleaned. The patient

stood silently by, watching without any obvious sign of annoyance as two staff members began to shift the piles of junk. He made no move either when some mice ran out from behind the yellowing newspapers, sending the female cleaner shrieking into the corridor.

At this, the man began to search around in the jumble, evidently looking for something. When he found a piece of paper, he sat down on the bed and began to draw. Whether the picture was intended to be a joke, the subject was immediately recognizable to the cleaners as they again got on with their work.

The pencil sketch was of a grinning cat with saucer-shaped eyes and

ONE OF LOUIS WAIN'S SKETCHES MADE IN THE BETHLEHEM HOSPITAL IN THE LATE 1920S

a rather distorted body and legs. Clearly the man who had drawn it was no ordinary patient; indeed, he had once been the most famous cat artist on earth and the creator of a unique world known as Catland. His name was Louis Wain.

When I was a child growing up in the years after the Second World War, I clearly remember a very strange little book that belonged to one of my cousins. It was entitled, innocently enough, *The Louis Wain Kitten Book.* It was about three inches square with a picture on every right- hand page and rhyming verses on the opposite page.

The kitten of the title was a mischievous creature with big eyes and a habit of getting into trouble. There was one illustration of the cat that caught my eye and struck me as very bizarre – as it still does today. The animal is lying on its back, reacting in horror to a man in Oriental clothes. The verse on the facing page read:

THE CURIOUS ILLUSTRATION IN *THE LOUIS WAIN KITTEN BOOK* (1903)

> This cat had always lived at home upon its master's lap,
> So it was very frightened when it first beheld a Jap.

I had to turn over the page quickly to learn that – as in all the best children's storybooks – the incident had a happy ending:

> But it very soon was brave again and sorry for its folly,
> When it found the little Jap was nothing but a sawdust dolly.

Today such a verse would no doubt be considered very politically incorrect. But I had never seen anything like it back in the 1950s, and it made a lasting impression. I may well have wondered who could have written such a strange story, but it was not until many years later that I found out who Louis Wain was and appreciated that the man and his life had been every bit as strange as some of his drawings. I also discovered that the book was in fact the only one that he had both written and illustrated among the two hundred or so titles bearing his name and that it had appeared at the very height of his fame in 1903.

It would take further research for me to learn that Wain had played a major part in making the cat the most popular of all domestic pets; that he had created a character, Peter, who deserves to be ranked alongside such classic animal storybook favourites as Winnie the Pooh and Rupert Bear, not to mention being a source of inspiration for the early stars of animation, Felix the Cat and Mickey Mouse; and that his life had ended in obscurity, penury and schizophrenia.

Only his artwork has survived to reveal the genius of Louis Wain's Catland and to offer an insight into the life of the man who was once described as 'The Edwardian Cat Artist That Went Mad'.

ONE OF THE MESMERIZING DRAWINGS WAIN MADE FOR ROY COMPTON

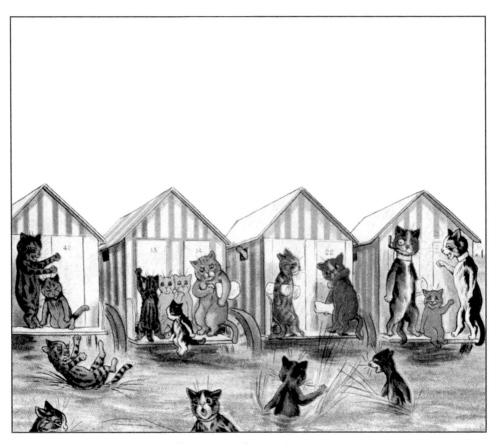

'A Day at the Seaside', c. 1898

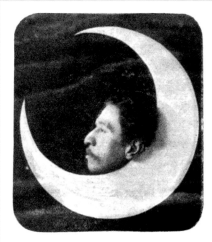

A BIZARRE PHOTOGRAPH OF WAIN TAKEN FOR *THE IDLER* IN 1895

Louis William Wain was born on 5 August 1860, in Clerkenwell, London, the eldest of six children of William Wain, a textile salesman, and his wife Julie, a designer of church fabrics. His birth was followed by that of five sisters: Caroline in 1862, Josephine two years later, Claire in 1868, Felicie early in 1871 and the last girl, Marie, just before Christmas of that same year. Wain might also have had a brother in 1866, but the infant was stillborn.

It seems that the eldest Wain child suffered poor health and did not go to school until he was ten years old. In the interim, he became prone to dreams, loved reading adventure stories set in far-off locations and invented fantasy worlds of his own. His education began at the Orchard Street Foundation School in Hackney and continued until 1877 at St Joseph's Academy in Kensington, where other

pupils remembered him as an outsider who often seemed lost in thoughts he would not share. In fact, he was already contemplating a career as a professional artist, as he was to tell journalist Roy Compton who interviewed him for *The Idler* just before Christmas 1895. In the subsequent article, which appeared in the January issue with a curious photograph of Wain peering through a crescent moon alongside a sketch of a cat's head he had made especially for the magazine, he said:

> My mother tells me that in my childhood I had always a great appreciation for colouring and used to amuse myself for hours grouping shaded leaves. I used to wander in the countryside studying nature and I consider that boyish fancy did much towards my future artistic life, for it taught me my powers of observation and to concentrate my mind on the details of nature which I should otherwise never have noticed.

Determined to follow his instincts, Wain took a two-year course at the West London School of Art. Following this, he remained as an assistant teacher for another two years – partly out of necessity, as his father had died in

1880 and he now had to support his mother and five sisters. He did, however, begin trying to sell drawings to newspapers, magazines and even printers to supplement his income. These early works of art are said to have been clearly inspired by his admiration for Phil May, whose combination of observation and amusing caricature earned him the epithet 'the Grandfather of British Illustrators', Randolph Caldecott, whose children's books made him the 'Lord of the Nursery', and the cartoonist Harry Furniss, to whose magazine *Lika Joka*, launched as a rival to *Punch*, he would later contribute.

Louis Wain's own years of observing nature finally enabled him to sell his first freelance drawing, 'Bullfinches on the Laurels' to the *Illustrated Sporting and Dramatic News* in December 1881. Unfortunately, the painstakingly detailed picture was wrongly captioned 'Robin's Breakfast' – and, although Wain submitted another thirty drawings without success, his style so impressed the magazine's proprietor, Sir William Ingram, that the following year he was offered a position on the staff. Also that same year he fell in love with Emily Richardson, the governess employed to look after his younger sisters. Despite the fact

she was ten years older than Wain and the family opposed their courtship, the couple were married in January 1884.

The marriage was to prove tragically short-lived – although it did provide the inspiration that would spark his career and put him on the road to fame. Shortly after setting up home in Hampstead, Emily Wain was found to be suffering from breast cancer and spent much of the remaining three years of her life in bed. To comfort and amuse her while Wain was working, a black-and-white kitten, named Peter, was introduced into the household. Of this cat Wain said later, 'To him properly belongs the foundation of my career, the development of my initial efforts and the establishing of my work.'

There are differing stories of how Peter came into the artist's life. One version claims that he was a stray who wandered into the house one day and stayed. Another says that he was given to Wain as a twentieth-birthday gift, while a third insists that he was a wedding present to Wain and his bride from his sisters. Whatever the truth, Peter's arrival was to prove a defining moment in the artist's life, as he also confessed to Roy Compton:

I had difficulty in obtaining a foothold, and started by making sketches for the *Illustrated Sporting and Dramatic News* at agricultural shows all over the country and got a keen insight into rural life. But it was Peter who first suggested to my mind my fanciful cat creations. I watched his antics one evening and I did a small sketch. Then I trained Peter like a child, and he became my principal model and the pioneer of my success. I suggested an idea to Sir William Ingram who had encouraged me greatly by taking some of my sketches which showed promise but were not sufficiently good to reproduce. I worked upon the cat pictures until they finally caught his fancy.

Wain's first accepted cat picture did not, however, makes its appearance in the *Illustrated Sporting and Dramatic News* but in Sir William's companion weekly magazine, the *Illustrated London News*, to which Wain had already contributed several illustrations as a freelance artist. Notable among these were 'Odd Fish' – featuring a 'Rabbit Fish' and a 'Parrot Fish' but curiously no 'Cat Fish' – and a report with sketches of 'The New Dog Fancy'. The multi-panelled full-page illustration entitled *Our Cats: A Domestic History* that Wain contributed the issue of 18 October 1884 is today acknowledged as a

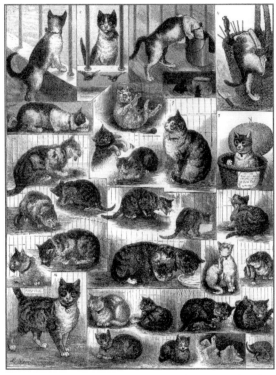

'OUR CATS: A DOMESTIC HISTORY', LOUIS WAIN'S
GROUND-BREAKING NARRATIVE DRAWING;
THE ARTIST'S CAT, PETER, IS FEATURED IN
PANELS 1–6, WITH THE PRIZE-WINNING
JONES' CAT IN PICTURES 7–14
(*ILLUSTRATED LONDON NEWS*, OCTOBER 1884)

ground-breaking example of a narrative drawing featuring animals.

The picture is a superb evocation of the cat in all its moods, with Peter appearing in no less than six of the panels. The artist's pet lets his sense of mischief get the better of him in several incidents, with the consequence that another cat belonging to the neighbouring Jones family is sent in his place to the Crystal Palace Cat Show where it wins first prize!

It seems safe to assume that the narrative – like all the other panels – was drawn from life. But far from the incorrigible Peter suffering as a result of his behaviour, he was destined to become hugely popular with the public; a popularity generated by dozens of drawings of the black-and-white cat with his unique markings that made him immediately recognizable in magazines and books and inspired the first attempt at creating an animated cartoon film *Pussyfoot* a decade ahead of Walt Disney's Mickey Mouse.

If one picture assured Louis Wain's fame it was *A Kitten's Christmas Party*, which Sir William Ingram commissioned for the Christmas 1886 issue of the *Illustrated*

London News. The artist worked on the drawing as if his very life depended on it, drawing almost two hundred lively-looking cats enjoying a Christmas revel. When it was published, the illustration created a sensation, and, in order that even more people might enjoy the idiosyncrasies of the cats, Sir William later presented the original to the Victoria and Albert Museum in London for public display.

Tragically, only a week after this triumph – on 2 January 1887 – Emily Wain died. Despite the brevity of their marriage and his wife's poor health, Wain was heartbroken, and to some people he was never the same man again. He grew shy and morose and shortly afterwards moved to lodgings in New Cavendish Street. His only comfort was Peter, who would live for almost another decade before dying peacefully in 1898 – his features and character already immortalized.

It would be in another Christmas edition of the *Illustrated London News* in 1890 that the anthropomorphized Louis Wain cat that became so familiar to admirers was first established. For *A Cat's Party* Wain took the elements he had begun to develop in his earlier festive gathering and is credited with being the first artist to depict clothed

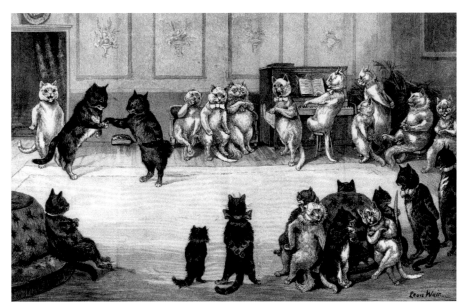

'A Cat's Party', Wain's second landmark illustration for the *Illustrated London News* (Christmas edition, 1890)

animals standing upright on two legs. His cats were portrayed chatting to one another, listening to a piano player and singer and generally behaving in exactly the same way as men and women in any household at that time

'EYE'S FRONT!' A MORE FORMAL WAIN CAT PICTURE (*LEISURE HOUR*, 1895)

of year. Readers everywhere were entranced, and Wain would no longer have to worry about commissions for years to come.

Not all publishers wanted his comical cats, however. Some, such as the editor of the magazine *Leisure Hour*,

required cats to behave like cats, as the charming example that illustrated an article 'Cats' by Hopkins Tighe in the February 1895 issue demonstrated. However, the *Illustrated London New*'s sister paper, the *Illustrated Sporting and Dramatic News*, was happy to encourage Wain to create more cats with human characteristics and a whole range of mannerisms and facial expressions. Some of his cats even began to behave like children – occasionally mischievous and naughty children – of which *The Little Nipper*, published in the *Illustrated Sporting and Dramatic News* in July 1898, is a perfect example.

The appeal of Louis Wain's cats was also to have a profound effect on the public's attitude towards the feline

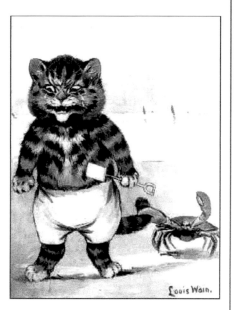

'The Little Nipper', one of Wain's typical mischievous kittens (*Illustrated Sporting and Dramatic News*, 1898)

species in general, as he was to claim some years later – with no sense of false modesty – when quoted by the *Evening Times*:

> I have tried to wipe out, once and for all, the contempt in which the cat has been held in the country and raised its status from the questionable care and attention of the old maid to a real and permanent place in the home. I have myself found, as the result of many years' inquiry and study, that all people who keep cats, and are in the habit of nursing them, do not suffer from those petty little ailments which all flesh is heir to, viz. nervous complaints of a minor sort. Hysteria and rheumatism, too, are unknown, and all lovers of 'Pussy' are of the sweetest temperament.

While Wain's claims for the 'curative' powers of the cat might be regarded with some amusement, there is no hint in his words that he had any suspicion of the ill health that would eventually blight his own life. Indeed, he was soon being regarded as an expert on the feline species and, in 1890, was invited to become president of the National Cat Club. He joined in enthusiastically with the club's activities – devising its badge and the motto

'Beauty Lives By Kindness', encouraging scientific breeding of the more exotic cats and instituting the first feline stud book.

Biographer Michael Parkin has thrown additional light on some of the artist's strange ideas and unusual theories about cats in his excellent study, *Louis Wain's Cats* (1983):

> According to Louis, the frailty of the cat's brain causes the cat to dislike change, so that when separated from its original home it often returns over incredible distances. The cat, he suggested, has it own compass that works through the electrical strength of its fur being attracted by either the negative or positive poles of the earth, thus pointing it in one direction or another. A cat washes not only to clean itself, but, according to Wain, 'to complete an electrical circuit, for by doing so it generates heat and therefore a pleasing sensation in its fur'. He also told an audience, 'Intelligence in the cat is underrated', pointing out that although the cat was regarded as sacred in Egypt and Siam, it was now up to modern man to undertake its training. Once the animal had been trained for three or four generations it showed its development, he said, in 'manners, intelligence and facial expression'.

Perhaps the most controversial moment of his presidency of the club came during a 'mad dog' scare in 1893. The front page of the April issue of the Royal Society for the Prevention of Cruelty to Animals' journal, the *Animal World*, carried one of Wain's sketches of a large furry cat confronting a cowering muzzled puppy. The picture was a satire, the paper reported, going on:

Louis Wain conceived the idea, first of all, that if dogs are to be muzzled, then puppies ought to be muzzled because they can bite and they can convey the virus into the human body. The poor miserable puppy teaches us a lesson by the expression of his countenance, as well as by his hopeless inability to lap water, which he sees in a bowl near him. He cuts a very

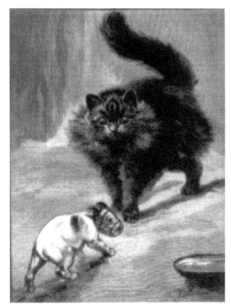

LOUIS WAIN'S SATIRICAL 'MUZZLED PUPPY' ILLUSTRATION
(*ANIMAL WORLD*, 1893)

different figure to the energetic and plucky feline, who looks at him not only with astonishment but indignation. Puss may well be proud, for the clever people who have muzzled dogs have forgotten that the bite of a cat affected with rabies is considerably worse than that of a dog. Her contempt for the puppy before her seems to suggest also an intense admiration for the human race, who have regarded her as possessing qualities superior to the canine degeneration of rabid maladies.

Yet the contrary would be the fact if a wandering mad dog should overtake her on the highway and impregnate her body with his poisonous virus. It is strange, therefore, that the authorities have not ordered that every cat should be muzzled, as well as every dog, and still more strange that horses and oxen and sheep and goats, which are constantly on the highway, should not also be muzzled, seeing that if bitten by a rabid animal undoubtedly they would take on the disease and be able to communicate it to other animals. This reasoning, which is unassailable, reduces the wisdom of the authorities in regarding the muzzle as a preventative measure to be *reductio ad absurdum*. As we have said before, the picture is a satire – and now, we will add, an argument also.

But Wain was not solely absorbed in the world of cats at this time. In 1894, he was once again reunited with his

mother and five sisters – his newfound success enabling them all to move to a house in the pretty resort of Westgate-on-Sea, near Margate on the Kent coast – where he could work and pursue some of the outdoor hobbies he had enjoyed in his youth. He made regular train journeys to London to see publishers as well as meeting up with fellow artists, including two of the men he had admired for so long, Phil May and Harry Furniss.

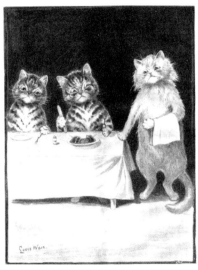

'WAITER! THIS CATS' MEAT IS TOUGH!'
A CARTOON CLASSIC
(*THE STRAND*, 1896)

During the 1890s and the early years of the twentieth century, Wain worked for a number of the most popular magazines of the time, including the *English Illustrated Magazine*, *Windsor Magazine*, *Cassell's*, *The Boy's Own Paper* and *The Strand*, the latter then enjoying phenomenal success serializing the Sherlock Holmes stories by Arthur Conan Doyle.

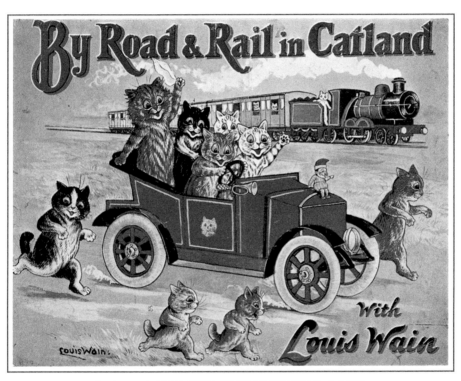

A POPULAR COLLECTION OF WAIN SKETCHES, *C.* 1910

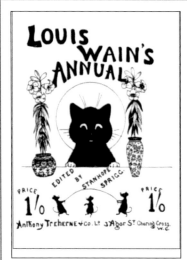

THE FIRST ISSUE OF *LOUIS WAIN'S ANNUAL*, WHICH WOULD BECOME A YEARLY BESTSELLER

It is from the pages of these now long-defunct magazines and similar ones which are all now highly prized collectors' items that the pictures in this book have been largely selected. Many of Wain's magazine sketches and illustrations were also reused in books, which have provided another source.

In 1901, for example, the London publisher Anthony Treherne of Agar Street near the Strand felt the artist's popularity was such that he could publish *Louis Wain's Annual*. An editor, Stanhope Sprigg, was assigned to commission stories and poems, while Wain busied himself making a selection of seventy illustrations from his published work, adding a number of new pieces. The few copies of the annual that have survived bear witness to the fact that the book was neither the slickest nor the best-produced of the year, but none the less worth the effort for

all concerned, as another biographer, Rodney Dale, has explained in his well-researched book *The Man Who Drew Cats* (1991):

> It is not clear whose idea the Annual was but, judging by its production and by the design of the cover, it was a hurried effort. But, however it came into being, it was a huge success and further increased Wain's fame. It continued to be published for many years [until 1921], and, although it hardly seems to be a children's book, it was an eagerly awaited Christmas present by thousands of children who 'marked the years by its appearance'.

The first decade of the twentieth century was to see Louis Wain at the peak of his fame. Newspapers, magazines and major book publishers, including Ernest Nister, James Clarke and Blackie, clamoured for his work, and postcard publishers and advertisers also sensed the appeal of his unique cats to make profit and sell their products. Raphael Tuck, who published dozens of books with Wain's illustrations, also issued postcards of amusing incidents in Catland that found a ready market and have since become very collectable. Notable among these was a series issued during the First World War

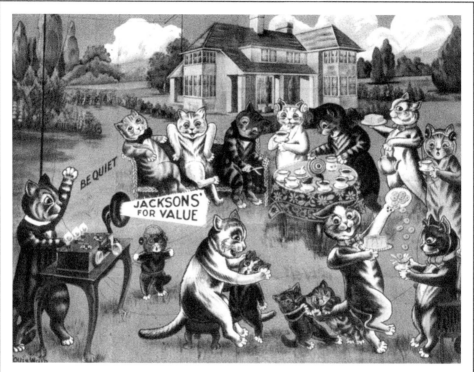

ONE OF A SERIES OF ADVERTISEMENTS WAIN CREATED FOR JACKSON'S OF PICCADILLY

featuring Tommy (C)atkins. Wain also drew a number of posters of cats holding tea parties and picnics for the London tea makers Jackson's of Piccadilly.

Excellent as his coloured pictures were, Wain believed strongly in the power of the black-and-white sketch, foreseeing the enduring impact of the newspaper cartoon, as he told Roy Compton during their chat:

> I think the black-and-white man has a brilliant future. At the present moment he is his own enemy, for his tendency is to work in a groove instead of entering into the spirit of the age and being sensitive to all its crazes, advancements, prejudices, and teachings. Personally, I work for every paper in turn, for I find from experience that if you work for one editor you get one class of ideas, and if you constantly change you avoid degeneracy. A man should never allow his fancy to run away with his judgement. His sketches should be the result of accurate insight into and appreciation of the variety of characters he has to please: he should be a very mirror held up to the nature amongst which he moves.

Louis Wain may well have been blessed with foresight, but, when it came to ensuring his own future, he was hopeless. He disliked having to bargain with editors for

his work, often accepting far less for a picture than it was worth and invariably giving away all rights. The more unscrupulous of his publishers undoubtedly took advantage of his attitude and endlessly reprinted Wain's illustrations without paying a penny more to their poor creator.

Perhaps, inevitably, he fell into debt, and by 1907, unable to obtain sufficient work in Britain, he decided to accept an invitation from Heart Newspapers to cross the Atlantic and draw his cats for American readers. He arrived in New York at the end of October and was soon hard at work. Wain decided to revive another of his favourite cats, Grimalkin, the 'thin and lengthy of limb' feline he had originally created for *Girl's Realm* in 1905. Soon his new readers were enjoying the sleek cat becoming involved in all manner of incidents from exploring the bustling street life of New York to learning the latest dance craze.

GRIMALKIN, WHO BECAME A FAVOURITE NEWSPAPER CARTOON-STRIP CHARACTER WITH US READERS

'Grimalkin' was launched in the United States in the *New York Journal-American* just before Christmas 1907 at the same time as the press were declaring Wain to be 'the world's most famous cat artist'. The popularity of the strip led to a second series, 'Cats About Town', which was also syndicated across the country and puts Wain firmly among the pioneers of the strip cartoon. His association with the National Cat Club also brought him invitations to meetings of the American Cat Fancy and their clubs across the nation. The artist's intention of staying in America for four months soon stretched into two years – but ended in disaster, as Kevin Nudd explained in *Book and Magazine Collector* in August 1992:

> Wain had hoped to make his fortune in America, but foolishly invested all his money in a 'wonder invention' – a lamp that used virtually no oil – which, owing to the outbreak of the First World War, was never developed. In the event, he returned home with his finances in a worse state than when he had left two years earlier.

Misfortune piled on misfortune for Wain. During his return sea voyage, his mother, who had become senile,

died, and he arrived back in Kent with virtually no money to support either himself or his sisters. Still, he persevered in trying to sell his drawings, but, one day in 1914, in a distracted frame of mind he fell from the platform of a swerving London bus and was taken to St Bartholomew's Hospital suffering from concussion. His first words on regaining consciousness were said to have been 'Is the cat all right?', although there was no indication that a cat had caused the driver to brake. Some sources have attributed the start of Wain's decline into madness to this accident.

In 1916, with the war raging, Wain and his sisters moved from the Kent coast back into London and a much smaller house in Kilburn. The money from the *Louis Wain Annuals*, together with a few commissions for other books and some cinema posters, just about kept the family from penury. The posters also opened the door for Wain to achieve another first when a pioneer film producer, H.F. Wood, who was based at Shepperton Studios, approached him.

Wood, it seemed, had been an admirer of Wain's work ever since the 1890s. He had particularly enjoyed *Peter – A Cat O'One Tail: His Life and Adventures* published by the *Pall*

PETER, LOUIS WAIN'S PET, WHO
INSPIRED THE WORLD'S FIRST
ANIMATED CAT MOVIE IN 1917

Mall Gazette in 1892. This slim volume, which featured the artist's cat in a series of adventures at a bird market, the Royal Butcher's shop and at a circus side-show complete with a mermaid and several freaks, had been written by journalist Christopher Morley with Wain providing the illustrations. H.F. Wood thought a cat such as Peter would make an ideal subject for a series of animated cartoon films.

Once again Wain threw himself into the new project with all the energy he could muster, hopeful of reviving his finances Although he was by nature a quick worker – more than one witness has stated that he could draw one of his familiar cat faces in under fifty seconds – he found producing sixteen separate pictures for every second of film that would appear on the screen extremely taxing. Wood and the artist settled on the name Pussyfoot for the

screen character, and the initial ten-minute animated film was completed early in 1917. The first ever film cartoon cat was screened in London that spring, just a few months ahead of the début of the Australian-Irish cartoonist Pat Sullivan's Felix the Cat, often credited with the honour. Sullivan, who had begun his artistic career drawing for *Ally Sloper* magazine in London, was already one of the highest-paid artists in Hollywood, thanks to the kind of financial acumen that Wain so painfully lacked.

Felix, of course, would go on to star in over a hundred animated cartoons and become an enduringly popular star of newspaper strips, comic books and television. Ten years later, Pussyfoot and Felix would be followed by Walt Disney's imaginative use of every cat's favourite prey to create the icon known as Mickey Mouse. On Wain's death, however, only one newspaper, the *Sunday Referee*, truly acknowledged the British artist's part in this sequence of events in an article entitled 'Mickey Mouse Had a Cat for an Ancestor'.

Sadly, there was to be no great success for the cartoon film *Pussyfoot*. George Pearson, the Oxford-educated schoolmaster turned innovative film-maker who was one of

the guiding lights of the embryonic British film industry, encouraged Wain while he was working at Shepperton and later describe the artist's unhappy experience in *Flashback: The Autobiography of a British Filmmaker* (1957):

> I did my utmost to help his cartoon work, but the strange technique was difficult for him, although he strove with painful slowness to produce the animation which he knew was essential. Some three or four cartoons were completed, but their cinema success was not great and in the end the venture was quietly abandoned.

There is no doubt that Wain would have dearly loved *Pussyfoot* to be successful and create a place in cinema history – he did, however, mention it in his entry in *Who's Who* – as well as earn some money. Interestingly, cinema historian Denis Gifford, who researched the association between the artist and George Pearson, claimed that Wain used the bulbous, staring eyes of one of his screen favourites, Lewis Montagna, as the model for the huge eyes of his cats. Apparently Wain had seen the hulking, pug-ugly Montagna in several silent movies playing dumb crooks and later enjoyed the actor's best role as the

ape-man in the 1925 version of Arthur Conan Doyle's *The Lost World*, starring Wallace Beery as Professor Challenger. After finishing his career in Hollywood, Montagna became a professional wrestler under the name of Bull Montana.

The year 1917 was to bring another tragedy for the Wain family with the death of a second sister. Seventeen years earlier, the youngest girl, Marie, had begun to suffer from delusions that she had leprosy and was diagnosed as having 'primary dementia' and sent to a mental home, Chartham Hospital in Canterbury, where she died in March 1913. Four years later, it was the fate of the oldest sister, Caroline, to catch bronchial pneumonia and die. Her death had a profound effect on Wain, whose mental health had also begun to decline, and he started directing his anger at the three remaining women whom he accused of stealing money and clothes from him.

When Wain became physically violent towards his sisters – pushing one of them down the stairs – they had no alternative but to summon a doctor. Like Marie before him, Wain was diagnosed as suffering from dementia and committed to the Surrey County Mental Asylum in Tooting. Despite his surroundings, however, he continued

to draw, and it was here, finally, that the real cause of his illness was diagnosed, as Dr Thomas Stuttaford, *The Times's* medical correspondent, explained in his column in August 2001. Stuttaford said he had a particular inter-est in the case as his chief in one of his first hospital appointments had actually helped to look after Wain:

Unfortunately, as Wain's dis-ease progressed, so did his grasp on reality diminish and his intellect crumble. He continued to paint in hospital, but the images became more distorted. It was of constant interest to the junior hospital staff that the more eulogistic the critics became, the worse was his schizophrenia.

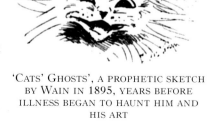

'CATS' GHOSTS', A PROPHETIC SKETCH BY WAIN IN 1895, YEARS BEFORE ILLNESS BEGAN TO HAUNT HIM AND HIS ART

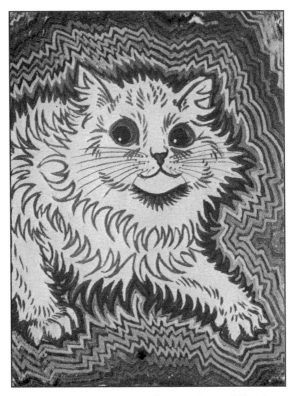

ABOVE AND FACING PAGE: TWO OF LOUIS WAIN'S
INCREASINGLY BIZARRE CAT DRAWINGS

Where his cats had previously been only lovable and comic, they now appeared increasingly aggressive, frenzied, even evil, and would ultimately disappear into a kaleidoscope of shapes and colours. However, in 1925, when Dan Rider, a London bookseller, visited the asylum and saw 'a quiet little man drawing cats', he realized who the forgotten pauper was and vowed to do something about the situation. He contacted the media, and

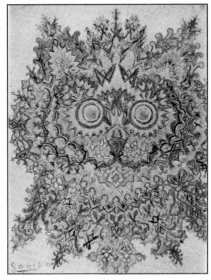

subsequent reports in *The Times*, a 'Louis Wain Competition Week' organized by the *Daily Graphic* and the public support of an influential group of sympathizers – including Princess Alexandra, Prime Minister Ramsey Macdonald, Sir Squire Bancroft and the authors John Galsworthy and H.G. Wells – raised enough money for Wain to be moved to the Royal Bethlehem Hospital. Here

the facility of his own room and a place to keep his possessions provided him with a settled environment where he could draw whenever the fancy took him.

In May 1930 – after the Bethlehem had itself been moved again to Beckenham – Wain was transferred to Napsbury, a mental hospital near St Albans, situated in beautifully landscaped gardens that teemed with wildlife. In these idyllic surroundings he again worked occasionally on his easel or sketchpad, although many of the pictures revealed the state of his increasing schizophrenia. When what would prove to be the last public exhibition of his work was mounted at the Clarendon House Gallery in London in June 1937, the *Daily Express* ran a story headlined – less than sensitively – 'Artist in Asylum Paints On'.

Wain's days were, in fact, already numbered. His illness tightened its grip on his mind and body, and by the spring of 1939 he was bedridden and unable to speak. As the clouds of war began to gather on the horizon for the second time that century, Louis Wain breathed his last on 4 July 1939. He was seventy-eight years old. He was buried in Plot 3654 in St Mary's Cemetery, Kensal Green, alongside his equally ill-fated sisters Caroline and Josephine. (The

two other Wain sisters also died not long afterwards, Felicie in 1940 and Claire in 1945.)

The horrors of the Second World War combined again to overshadow Wain's gentle genius just as the first conflict had done. Almost half a century would pass before his achievements were to be acknowledged again. The past decade has seen the appearance of numerous articles and two volumes about his life and art, as well as a series of exhibitions of his artwork – thanks largely to the efforts of three

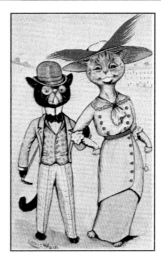

ILLUSTRATION FROM *LOUIS WAIN'S ANNUAL*, 1913

admirers, Brian Reade at the Victorian and Albert Museum and the art gallery owners Michael Parkin and Chris Beetles. The sales of prints and postcards made from his colour pictures have also increased, while books containing Wain illustrations – especially the scarce early volumes and *Annuals* – now fetch hundreds of pounds.

Two plays have recently focused on the artist's life, Jane

Cole's subtle portrait *Cat with Green Violin*, with its delightful humour that was staged at the Orange Tree Theatre in Richmond, London, in 1991, and the Canadian actor/playwright Rod Keith's *Fire in the Mind*, at the Arts Project in Ontario in 2003. This moving account of the artist's declining state of mind received excellent notices for its creator's *tour de force* as Wain and Rachel Holden-Jones's uncannily feline performance as Peter the Cat.

It was almost exactly a century ago that the distinguished English dramatist, journalist and editor of *Punch*, Sir Frank Burnand, aptly described Louis Wain as the 'Hogarth of Cat Life'. It was claimed in one of the artist's obituaries that during his life he had probably drawn over 150,000 pictures of cats, although it is certain that the true figure will never be known, so careless was he in his business dealings and so generous in gifts to admirers. In the pages of this book, I believe the reader will discover some of the evidence to support Sir Frank's assertion. I hope, too, that it will help to restore fully the reputation of an anthropomorphic artist every bit as unique as Edward Lear, Ernest H. Shepard and Beatrix Potter, whose appeal, like theirs, crosses all generations and all ages.

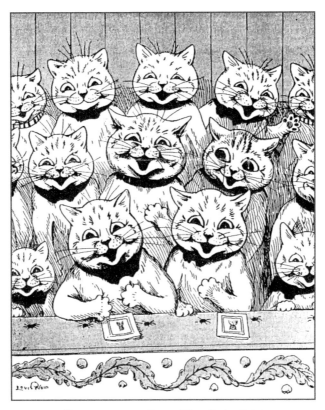

FROM THE LAST *LOUIS WAIN'S ANNUAL*,
PUBLISHED IN 1921

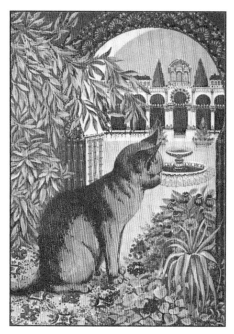

A CLASSIC WAIN PORTRAIT OF A BEAUTIFUL
CAT IN AN EXOTIC LOCATION

How I Draw My Cats

From *Home Notes*, 20 August 1898

To come to the point at once – you cannot draw cats as you would still life or any tractable model. They will neither be bullied, cajoled nor forced into a position for more than two seconds at a time. Unless your pencil is rapidity itself, you may as well give up at once.

Most of my own sketches have been done at fever pace, and consequently the whole of my work partakes of the same energy which I have learned to put in my original studies.

ROUGH SKETCH OF A
LONG-HAIRED CAT

'A KNOWING CAT'

It is easy enough to black in accentuated masses of tone to suggest your subject, but when you want to represent life itself, methods have to give way to nature, and this stage is the real crux of the artist's career.

You can never get variety in drawing cats by studying one or two specimens at home alone. My hardest work has been done at cat shows where you get different types of animals from every country and where the conditions of working in a crowd of moving people compel one to try a great deal harder than in sitting at home comfortably in a studio.

It is my invariable habit to conceive my subject mentally first and then carry it out while the humour of the subject appeals to me. If this feeling once goes, then goodbye to any chance of making anything out of the drawing.

One cannot make a cat laugh to carry conviction with it, without being in the laugh, as it were, oneself, I find. And I never attempt a humorous subject without at the same time feeling very happy with the world in general.

One's models, too, when used for serious studies, always develop moods and these moods are always the opposite to one's intentions. And so one has to resort to tricks to catch them unawares.

'THE PLUMP OR GOOD TYPE OF CAT'

For instance, cats love a sheet of newspaper or brown paper to sit upon and, once they have taken possession of it, it is difficult to move them away. Then, too, they are fond of fancy grasses and will stand in front of a vase of sedge grass for a time biting at it.

But occasionally you will come across a cat – generally one who always keeps its tail dropped well behind, a sign of confidence in the feline, by the bye – who is vain enough to be looked at and who will be quite happy if you only pet him occasionally.

A ruse of mine to keep a cat still is to put a high box on a chair, for cats love to sit on high, isolated places. Another, to hang something bright on the walls of my room to excite their curiosity. Transitory efforts like these are very tiring to follow, and a few hours of this rough-and-tumble sketching takes it out of one more than a very hard week's work over the drawing-board.

My own cats always seem to know that there is some-thing up when I want them, for they make for the garden and hide in a tangle of flower-beds or under the bushes and defy the whole establishment to catch them.

My old cat, Peter, who is fifteen years old and has quite

'THE THIN OR BAD TYPE OF CAT'

a warrior's record of illnesses overcome and accidents gone through, is the most independent of all my cats. He won't stand interlopers in the cat family circle, hates kittens passionately, and in his old age spends the greater part of his life lying on the kitchen hot-plate stove and seems to enjoy a degree of heat which the hand of the human could not bear. Many a cat has come and gone in the circle, but most of them have been put in order by Peter.

All my cats are very obedient. They know it is wrong for them to sit on the tables, or dig up the flowerbeds, or scratch the furniture, and never attempt to go beyond the limits of good taste. They are petted, but are kept in their place. They are fed with the regularity of clockwork and have a big dish of bread and milk laid out for them to go to all day long, summer and winter, and so are rarely in ill-health.

The rarest of all cats I have come across is the 'tickled' cat, the fur being speckled like a porcupine quill. The next in scarcity is the tortoise-shell tomcat. By tortoise-shell I mean the colours that you get, say, in a tortoise comb: yellow, red and black without a single speck of white.

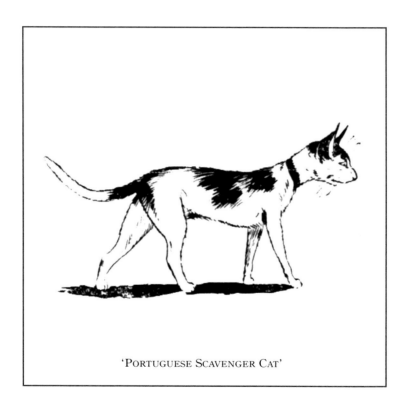

'PORTUGUESE SCAVENGER CAT'

They are plentiful in the north of England, especially in Lancashire, but are nearly all she-cats.

Another difficult cat to breed is the Siamese cat. It is the colour of cream, with the face, legs and tail mouse-coloured, and has very striking mauve-coloured eyes.

The scavenger cat of Spain and Portugal goes about in droves like sheep and takes possession of a town or village or church in a body. They often commit serious depredations on the poultry yard and larder before they go out into the world again to live. These cats rove through the woods and forests, climbing the trees like winged beings almost, and bringing down the strongest bird in the dead of night.

Some of them take to the mountains and become a scourge even to sheep and cattle in cold weather. They grow to an extraordinary size when their carnivorous tendencies lead them to blood-sucking the helpless sheep rather than to poaching the mountain feathered tribes. Strangely enough, these tendencies lead them to shun the sight of man, and consequently, as their taste becomes more savage, they retire further and further from the haunts of humanity and finally become tasty morsels for roving wolves.

'THE ROUND-FACED, LOVING CAT'

Our show cats in England are all getting round faced, shorter nosed and more cobby as they become more domesticated and better fed and cared for. The National Cat Club, of which Her Grace the Duchess of Bedford is president, is doing good work in rendering the different breeds permanent, so that the present-day cats exhibited at the National Cat Club Show show an exceptional amount of quality and command high prices, sometimes as much as £50 to £100 being given for a really fine animal. The latest novelty we are threatened with in the cat line is a Japanese hairless cat from Mexico.

PROFESSOR FREDERICKS' PERFORMING CATS

From the *Illustrated London News*, 22 December 1888

We all have our hobbies, which our friends, if they are wise, suffer gladly. Professor Fredericks' hobby is animals. The horse, the pony, the goat and the pig have all from time to time come under his influence. Just now he has a preference for the domestic cat.

He possesses a large number of cats, of all breeds and sizes, which are conveyed from his house to the place of performance each day, are exercised most mornings in his back garden and are fed on cats'-meat and bread and milk. Some of them persistently prefer the latter dish.

The pride of the flock is a black animal, named Sloper, who originally cost his master sixpence. A fifty-pound note

'SLOPER'

would not buy him today. This treasure is just now suffering from a severe cold, and the Professor has been obliged to put a mustard plaster on his throat.

Of all animals, horses and dogs are the easiest to train. Cats are willing enough to learn, but they are unreliable. Sloper may have walked the tightrope five nights with elegance and precision, but on the sixth he refuses. 'It's obstinacy,' says Professor Fredericks, 'and when the fit is on them, the only way is to let them rest. I never use force and never by any chance strike an animal.'

For training purposes, kittens are useless. They are too enterprising. Professor Fredericks prefers a

'I WILL NOT'

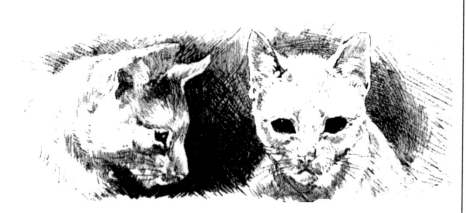

'PORTUGUESE CATS'

middle-aged Portuguese animal, whose sense of humour is not abnormally developed. Cats can be trained to care little about the audience and they are perfectly indifferent to applause; but they do not like any alteration in the aspects of the stage. If a stranger happens to cross the boards, they will pause and look around with a serious inquisitiveness which is inimitable.

The first item of the performance at the Oxford was climbing the pole. This, of all cat tricks, is the hardest to teach, as with the first step the animal passes out of his

master's jurisdiction. Whether he reaches the top of the pole or not depends entirely upon his humour. On this occasion Arco – a tall, thin, lank Portuguese cat – was in fine form. He climbed the pole and came down head first without so much as a mew.

Walking the tightrope followed. This half a dozen animals – English and Portuguese – accomplished skilfully with occasional encouragement from their master. If there is one thing of all others that Sloper most dislikes, it is mice

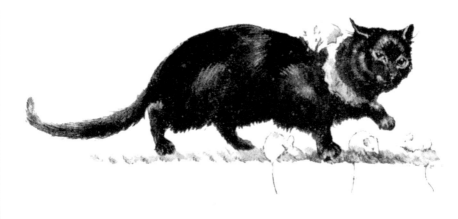

'ON THE TIGHTROPE'

and next it is canary birds. He treats both of them with contempt.

One of the striking features of the performance was to see him walk a tightrope literally strewn with these animals. He lifted his feet gingerly over mice and birds and the little mishap that occurred in the second part of the journey was due entirely to his severe cold. He sneezed one of the canaries off the rope on to the floor – but he made up for it by returning with a mouse on his back. It takes a canary about five weeks to get used to its natural enemy.

It will be news to most people to hear that one cat in eight has no taste for birds and mice. When the taste has been acquired, nothing save downright bullying and cruelty will correct it and that method of training has no place in Professor Fredericks' system. Quite recently a black-and-white member of the company, named Aquarium, by a clever piece of business, nearly succeeded in ousting Sloper from his position as leading juvenile of the show. In a moment of forgetfulness, let us hope, he bent his head and caught a mouse in his mouth. The little animal, no doubt, gave himself up for lost. A word from Professor Fredericks, however, and it was dropped at once.

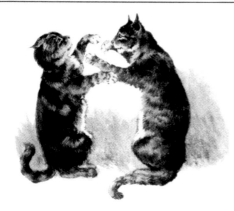

'Boxing'

Mention must also be made of the boxing cats. They stood on their hind legs facing one another on two chairs and fought three rounds in a most scientific fashion.

Professor Fredericks finds that Portuguese cats make the finest performers and the Lisbon folk the best audiences. In that city cats are adored, for the reason that they act as scavengers in clearing the streets of the innumerable mice that infest them. Their lank and lean appearance is due to this pursuit, and not to severe treatment as English audiences are apt to imagine.

Professor Fredericks is able to train one in three cats, those of a black hue taking most readily to the work. He first teaches them to sit up and beg; creeping through chairs comes next. This he follows by getting them to crawl over the backs of the chairs.

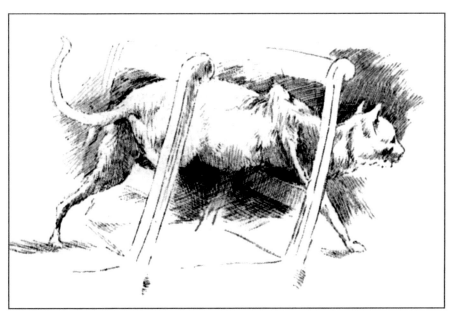

'WALKING THROUGH CHAIRS'

The Professor also teaches them to walk across the stage around champagne bottles followed by walking over the bottles, which I saw them perform with great dexterity at the Oxford.

The Professor believes that cats have no real affection at all. They can, with patience, be taught even the most daring feats such as the fiery hoop, which is guaranteed to startle even the most sophisticated audience.

There is not on record a single instance of a Radical Cat. They detest change and if taken to a new home will hide under the sofa or up the chimney until custom has soothed

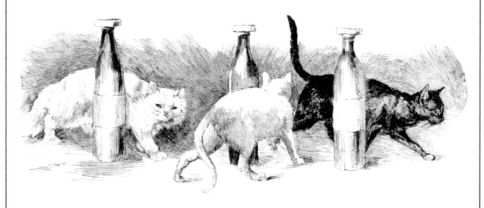

'WALKING ROUND BOTTLES'

their fear. It is one thing for a cat to perform in a private room, but quite another to make him go through his tricks in a public hall, as one or two showmen have found to their cost.

This power over animals is a rare gift and those who possess it are more interesting then they think. In this respect, I consider Professor Fredericks at the forefront of his profession and expertise.

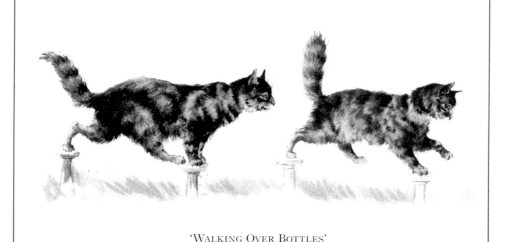

'WALKING OVER BOTTLES'

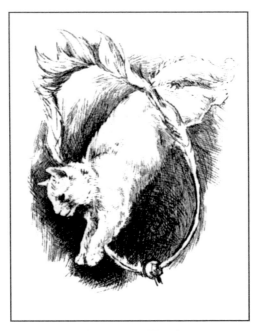

'THE FIERY HOOP'

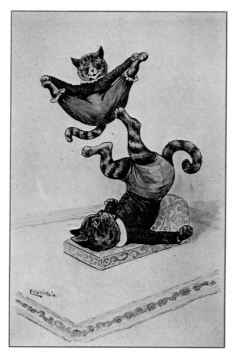

'Gymnastic Cats', a 1905 sketch

A Cat Compendium

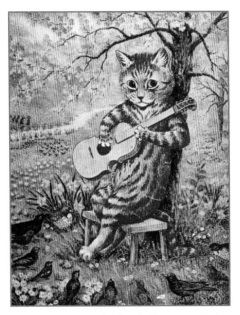

'The Audience' (*Girl's Realm*, 1905)

THE CAT'S PARADE

Louis Wain collaborated with a number of the popular early twentieth-century writers of children's stories, including Clifton Bingham, A.W. Ridler, E.H. Jeffs, Norman Gale, Grace C. Floyd, Cecily M. Rutley, Jessie Pope and Edric Vrendenburg, as well as the novelists Jerome K. Jerome, whose *Novel Notes* (1893) he illustrated with eighteen text illustrations, and W.L. Auden, whose bestseller, *Cat Tales*, was published in 1905. That same year, Wain provided a group of typically beguiling sketches to accompany a piece of cat poetry by Jetta Vogel for the July 1905 edition of the magazine *The Girl's Realm*.

• • •

Eight poor cats! See how they run!
There's the Yellow-and-White,
The Black and the White,
And the Tabby and Tortoiseshell one.

For the boy with his fish and his knife and
 his dish,
Is stopping at house Number One.
And along all the Row where his
 customers go,
The pussycats scamper and run.

The Persian looks out to see what's about
From the window of Number Three;
And the Manxman so brave, his tail he
 would wave,
But never a tail has he.

Grimalkin so thin and lengthy of limb,
From the garden of house Number
 Eight,
Comes in at a run ere the feast's begun,
In terror lest he should be late.

They stand on their tails around the boy
 with his scales
And beg for a bit of the spoil.
He smiles as he flings to the poor furry
 things,
Their share of the fisherman's toil.

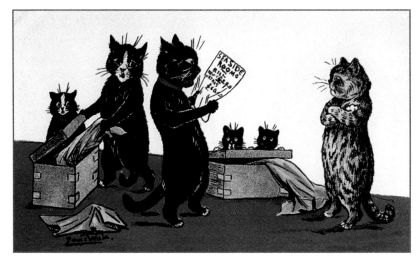

TYPICAL HUMOROUS INCIDENT (*LOUIS WAIN'S ANNUAL*, *C.* 1905)

NINE LIVES: THE PROVERBIAL LIFE OF THE CAT

Louis Wain loved the proverbs associated with cats and illustrated the best of these with wonderfully comic sketches in the pages of the yearly publication that bore his name, *Louis Wain's Annual*. Launched in 1901 by the London publisher Anthony Treherne, the book was to have several editors during its twenty-one-year run, including Stanhope Sprigg, T.F.G. Coates and R.S. Pengelly. Treherne ceased publishing the annual after the second issue and was followed by John F. Shaw, George Allen, Bemrose the Printers and Hutchinson, who issued the final volume in 1921. Although the text in the books was primarily by other writers, Wain would contribute the occasional poem and short article but apparently got most pleasure from putting his pictures to short stanzas. 'Nine Lives' appeared intermittently in the *Louis Wain Annual* between 1902 and 1915.

'GRINNING LIKE A CHESHIRE CAT'

'THE CAT'S WHISKERS'

'Enough to Make a Cat Laugh'

'SEE WHICH WAY THE CAT JUMPS'

'THE CAT THAT GOT THE CREAM'

'ROOM TO SWING A CAT'

'Cat-nip'

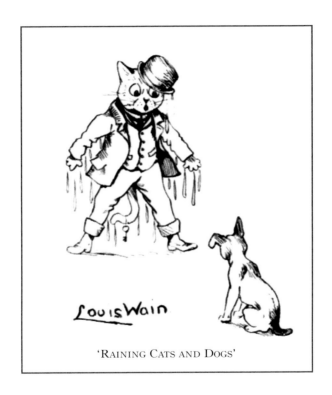

'RAINING CATS AND DOGS'

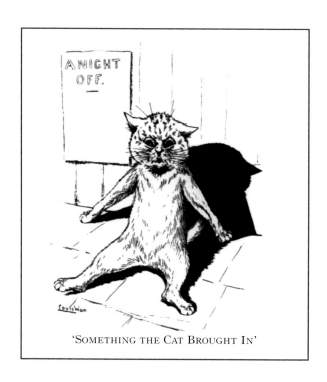

'SOMETHING THE CAT BROUGHT IN'

At Play
in Wainland

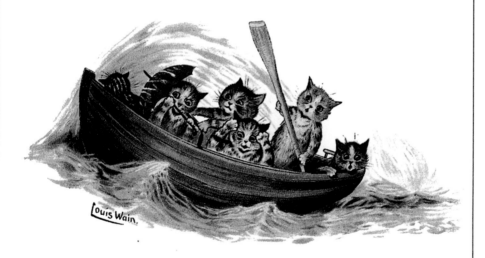

A large number of Louis Wain's cat sketches reflected his own interests and pastimes. Walking in the countryside observing nature had, of course, been a favourite relaxation ever since he was

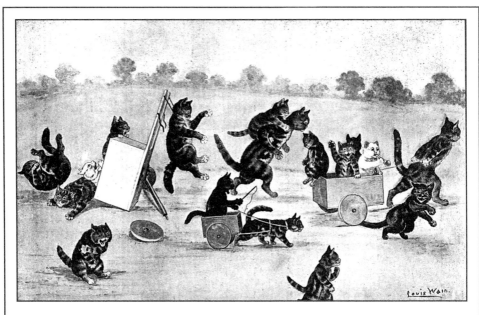

'A Day in the Country' (*Boy's Own Paper*, 1895)

a child, and his felines are frequently to be found enjoying a day in the open air, playing, picnicking or just having fun. Cycling gave him a lot of pleasure, too, and Rodney Dale in his biography reports that Wain applied for patents for three inventions: a 'Steady Cycle' in 1894, a 'New Attachment to Bicycles' in 1895 and, in 1915, a puzzling item of equipment called the 'Rangefinder', which

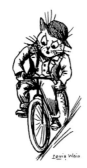

'THE NEW CYCLIST' (*IN CATLAND*, 1914)

could well be the ancestor of the modern bicycle computer.

Music was another abiding passion, and it has been suggested that as a young man Wain seriously considered becoming a musician. He loved classical music in particular and claimed to have composed a number of pieces, including an opera he submitted to Henry Wood in the hope that it might be performed on the London stage. This claim is open to some doubt, however – as is another that he trained to be a violinist – but this did not stop Wain from endowing several of his characters with similar interests, naturally with varying degrees of skill.

In the early years of his success, Wain endeavoured to keep himself fit by taking up

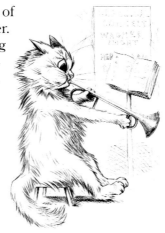

'HERR BLUTTZER HAS A COMPOSING FIT' (*LOUIS WAIN'S ANNUAL*, 1912)

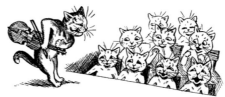

'AN ENCORE FOR THE MAESTRO' (*IN LOUIS WAIN LAND*, 1913)

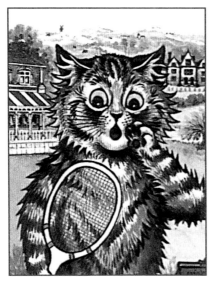

'ANOTHER WINNER!' (*LOUIS WAIN'S SUMMER BOOK*, 1906)

various sports, such as running, swimming and boating. He also belonged to the Westgate Tennis Club but was best remembered for his eccentric dancing at the club's dances rather than for any skill on the courts. There is a suggestion, because of the number of pictures he drew of cats fishing, playing golf and cricket, that he may have tried these sports, too, although his animal's lack of success may well mirror his own.

The one sport that really enthralled him was boxing. Friends remembered him sparring and taking part in a few fights, one of which left him with a broken nose. In 1911, he wrote several letters to the press calling for the establishment of a Boxing Board of Control to prevent mismatches and life-threatening injuries to fighters. Since his youth, Wain had been a great admirer of the British champion, William Thompson (1811–89), who fought under the name of Bendigo and won his first prize-fight in 1832. Thompson finally quit the ring in 1850 after a triumphant career, and his

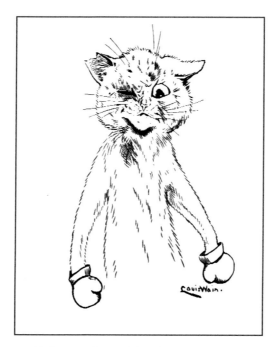

'A PLUCKY LOSER' (*IN WAINLAND*, 1919)

reputation internationally was such that it is claimed the town of Bendigo in Australia is named after him. Whatever the truth of this, Wain showed his admiration for the boxer by naming his house in Westgate-on-Sea 'Bendigo'.

In boxing, as in so many of the other sports, Wain's cats singularly failed to match the feats of their inspiration. The artist's own health and reputation was, of course, also battered by ill fortune, and it has certainly taken a long time for Louis Wain's Catland to be acknowledged as a truly original creation.

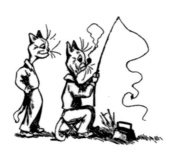

'A LESSON IN ANGLING' (*LOUIS WAIN'S ANNUAL*, 1903)

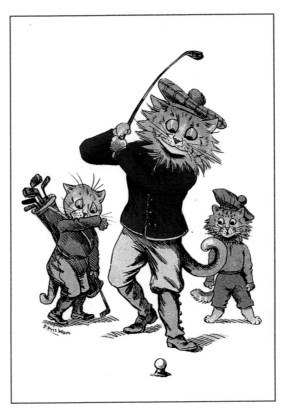

'TEEING UP A SHOT!'
(*LOUIS WAIN'S ANNUAL*, 1911)

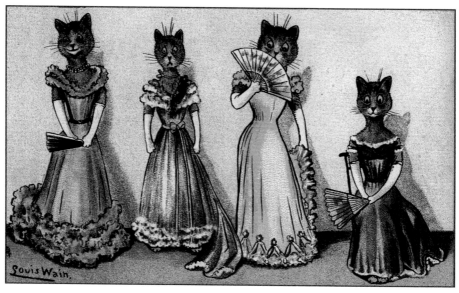

ONE OF LOUIS WAIN'S 'WALLFLOWER' ILLUSTRATIONS, FROM A POSTCARD COLLECTION
DESIGNED IN 1905 FOR RAPHAEL TUCK'S 'HUMOROUS' SERIES

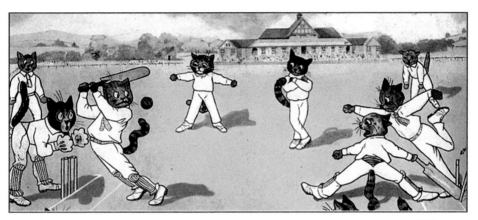

ALL KITTED UP – A MATCH IN FULL SWING FROM A POSTCARD OF AROUND 1910
ADVERTISING JACKSON'S HATS AND BOOTS

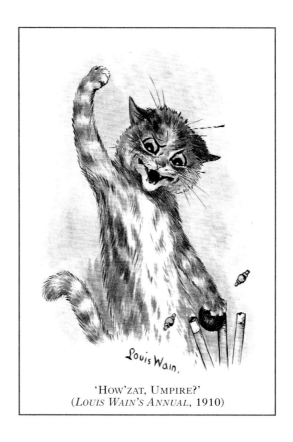

'HOW'ZAT, UMPIRE?'
(*LOUIS WAIN'S ANNUAL*, 1910)